POPSICLE-STICK-GRAFFITI

NUMBER TWO SIGNS

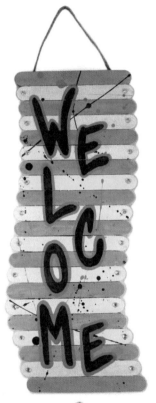

This book is dedicated
to my grandmother
Rita Sultan

CONTENTS

The projects in this book are made with regular popsicle sticks, jumbo popsicle sticks, or a combination of both. Regular popsicle sticks are approximately 4 1/2" x 3/8". Jumbo popsicle sticks are approximately 6" x 3/4". Sizes may vary depending on the brand. Popsicle sticks are made from real wood so you need to be careful when working with them, as rough edges can cause splinters. Buy both sizes of popsicle sticks by the hundreds in boxes at your local craft store.

Regular Popsicle Stick

Jumbo Popsicle Stick

If you want to design your own graffiti words for your signs, our two instructional books, "Learn to Draw a Graffiti Master-Piece," and, "Why Write When You Can Tag: Learn To Draw The Best Graffiti Tags Ever!", are a great place to learn graffiti lettering techniques.

Popsicle-Stick-Graffiti /Number Two/ Signs
First Printing, 2018
ISBN-13: 978-0-9904381-3-7
ISBN-10: 0-9904381-3-9
Published By Graffiti Diplomacy
Special thanks to Dr. Leonard Deutsch and Stephen Spiegel
DISCLAIMER: Do not draw graffiti on any public or private surface without permission. This is a book about painting graffiti art on popsicle sticks only.
Find us on the web at "graffitidiplomacy.com". For general information on our other products, please contact us at "graffitidiplomacy@yahoo.com".

INTRODUCTION & SUPPLIES

All of the signs in this book are made with graffiti words that I found around town or graffiti words I created myself. You can: (**A**) Paint your signs using different words in any style of letters you prefer to give them a personal touch, (**B**) Copy the projects/words in this book, or (**C**) Trace letters from the Graffiti Tag Letter Alphabet on pages 41-43 to design your own graffiti word. Use the Basic Instructions on pages 4-15 as a starting point to to build your sign in any size or shape that you like. Simply modify the instructions as needed. Use regular popsicle sticks, jumbo popsicle sticks, or a combination of both. Mix and match letters, words, sticks, and shapes to create an infinite variety of signs. Here are some general rules for making popsicle stick signs:

1 Popsicle-Stick-Graffiti signs are constructed using the Basic Instructions detailed on pages 4-15 with modifications made to the instructions as needed for each word.

2 All of the signs are painted with water-based acrylic paint and finished with a coat of water-based varnish. Use either matte varnish (non-shiny) or gloss varnish (shiny).

3 Graffiti word designs are transferred from paper drawings onto wood sticks using tracing paper, a #2 pencil, and the Pencil Transfer Method detailed on pages 9-12.

4 To construct a sign there must be interlocking crossed sticks glued firmly on the back to hold the sign together (kind of like interlocking your fingers). A sign needs at least two rows of interlocking crossed sticks, one near the top and one near the bottom. They can be arranged in any configuration, as long as they overlap at intervals, as shown below. Either regular popsicle sticks or jumbo popsicle sticks can be used for crossed sticks on the back of any sign.

CROSSED STICKS

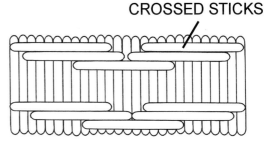

MATERIALS YOU NEED FOR SIGNS

Regular or Jumbo Popsicle Sticks
Tacky Glue (thicker and stronger than white glue)
String (yarn, hemp, rawhide, or any other kind)
Brown Kraft Paper
Masking Tape or Blue Temporary Tape
Tracing Paper and a Pencil (#2 or softer)
Acrylic Paints (Bottles or Jars)
Paintbrush/ Water Container/ Mixing Palette
Varnish or Shellac
Sandpaper - Medium Weight

DECORATIVE ELEMENTS - OPTIONAL

Assorted Wood and Plastic Beads
Wooden Dowel or Tree Branch
Rhinestones, Sequins, or Stickers
Magic Markers, Colored Pencils, or Crayons

EVERY SIGN HAS INTERLOCKING
CROSSED STICKS ON BACK
TO HOLD THE SIGN TOGETHER
(LIKE INTERLOCKING YOUR FINGERS)

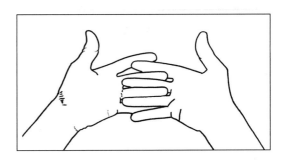

BASIC INSTRUCTIONS

These Basic Instructions can be used as a starting point to create any of the signs in this book. General rules for sign construction are as follows:

A) A sign is constructed with popsicle sticks arranged side-by-side in a shape designed to fit the word on the front. You can lay out the front sticks in any pattern as long as the word fits.

B) A sign has interlocking crossed sticks on the back to hold the sign together (see page 3).

C) Each sign uses the Pencil Transfer Method detailed on pages 9-12 to transfer a word design from drawing paper to the wood sticks. It is then painted with acrylic paint.

DESIGN A GRAFFITI WORD

STEP 1. To get started, choose a word (or name) for your sign.

Go to the Tag Letter Alphabet on pages 41-43 and pick out the letters you need to complete your word using one of these options:

a) Trace the letters with a pencil directly from the book,

b) make a photocopy of the pages for easier tracing, or

c) copy the letters by eye, free-hand.

You may choose to invent your own letters instead. Or use a graffiti word from a photograph. Design the word for your sign however you like. I picked the letters W-I-S-H for my example.

With a pencil, draw your graffiti word onto an 8 1/2" x 11" sheet of paper (or bigger), or a sheet of tracing paper.

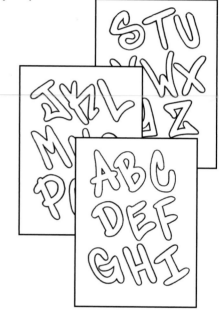

Tag Letter Alphabet
Pages 41-43

STEP 2. You can use the letters from the Tag Letter Alphabet just as they are, or you can modify them. Draw with a pencil so you can erase lines and make changes as needed.

TO MODIFY LETTERS:
I wanted to fatten my letters up a little bit. To fatten up letters, draw an outline around the outside of each letter all the way around. Make the letters as fat as you like.

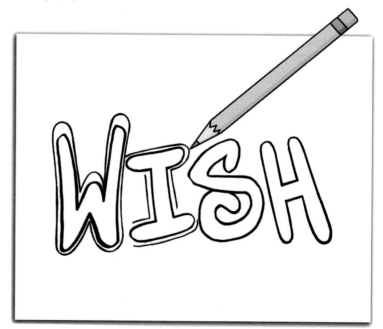

STEP 3. Go over the outlines of your drawing with a pencil, pen or black magic marker. Erase all unneeded lines and clean up the drawing. Make your letters bold so they are easy to read. Embellish the drawing with a star, a heart, or any other decorative element. Now you are ready to build the sign.

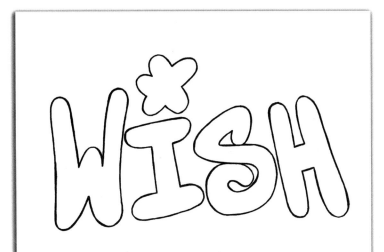

Clean, finished drawing ready for sign construction

Finished sign on page 15 for reference

CONSTRUCT THE SIGN

STEP 1. FRONT - To assemble the sign front, lay out popsicle sticks on top of your drawing, covering each letter, one stick at a time. Don't leave any space between the sticks. Line them up in a row evenly or stagger them up and down in an uneven pattern, as shown below. My example uses jumbo sticks, however you can use either regular popsicle sticks or jumbo sticks. You might need to adjust the size of the word depending on which size sticks you are using. You can even let part of the design disappear off the edge, like in the SIMPLE sign on page 17.

THIS EXAMPLE:
FRONT - 14 Jumbo Sticks

BACK - 8 or 16 Regular Popsicle Sticks
(one layer or two)

NOTE: There is no exact number or way to lay out the sticks. Just cover the letters and arrange them anyway you like.

STEP 2. Put several pieces of Masking Tape or Temporary Blue Tape across the popsicle sticks to hold them firmly in place. This is your sign front.

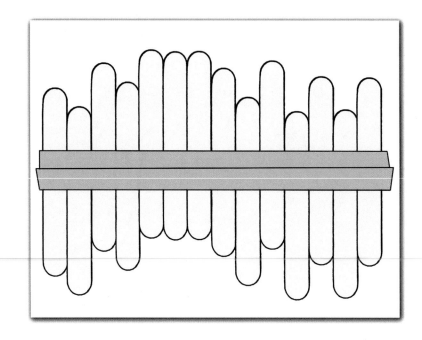

STEP 3. BACK - Turn the sticks over with the taped side facing down on your table. Spread glue over four regular popsicle sticks and glue them onto the back, near the top. Interlock the sticks, as shown below. These are the crossed sticks that will hold the sign together. Make a second row of crossed sticks near the bottom. NOTE: The two rows don't have to be exactly the same (see SUP! on page 24- the crossed sticks are reversed). You can even put three rows.

NOTE
Use extra thick tacky kraft glue when possible. It holds great and dries fast so is the best glue to use for signs. But plain, white glue will work well, too.

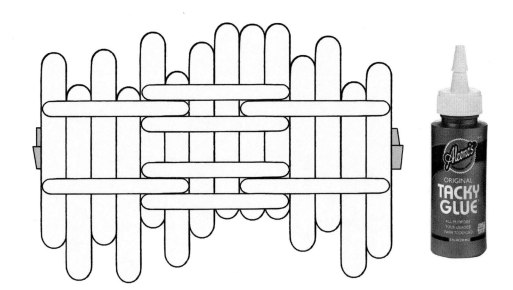

Interlocking Crossed Sticks Overlap At Intervals

STEP 4. When done, put a heavy book or some other weight on top of the sign to make it dry as flat as possible. When the glue is dry, remove the tape from the front.

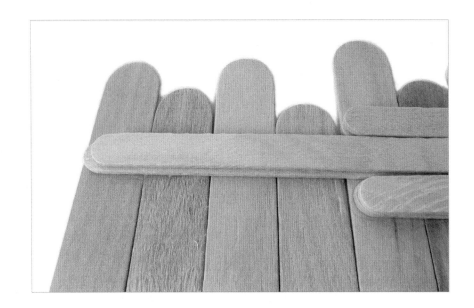

OPTIONAL
You can glue a second layer of crossed sticks on top of the first. If you are using jumbo sticks for the crossed sticks on back, a second layer is recommended because jumbo sticks are thinner than regular popsicle sticks, and the extra layer will make the sign much stronger.

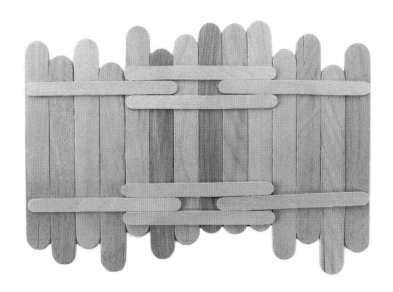

BACK
Whether you decide to use one layer of crossed sticks or two layers is totally up to you. One layer will work, but the second layer will make it a really firm sign.

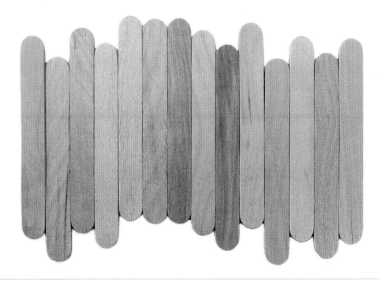

FRONT
When the glue is dry remove the tape from the sign front. Wipe the front and back down with a cold, damp cloth to prepare the wood for painting. Put the sign in a well-ventilated place to dry, and let it dry thoroughly.

You can trace this WISH drawing below to use on your sign. Or draw your own word. If you are using regular popsicle sticks, leave off the star on top so the letters will fit more easily on the sign front. You can also take a photo of this WISH drawing and reduce the size using computer picture editing software. Or scan and change the size on a photocopy machine. Your choice.

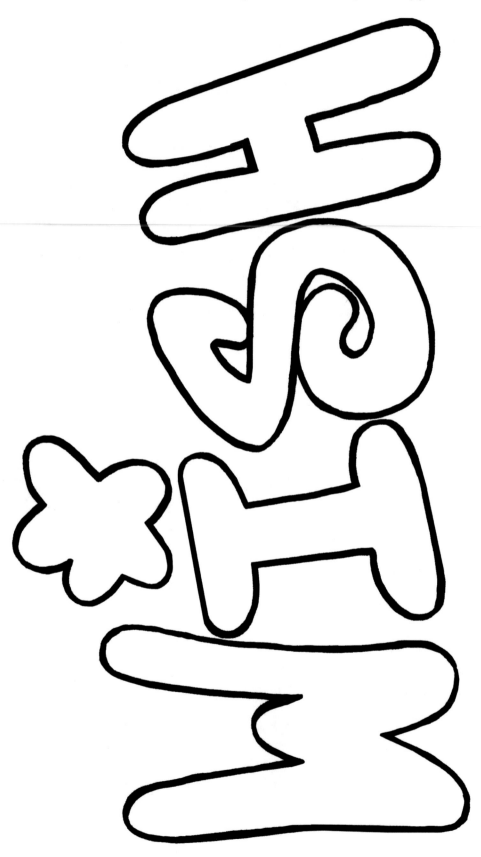

TRANSFER THE WORD FROM PAPER TO WOOD

THE PENCIL TRANSFER METHOD

STEP 1. Draw or print out your word design on a piece of paper at the appropriate size needed for your sign. Place a sheet of tracing paper over the drawing. You may want to secure the tracing paper to the drawing paper temporarily with tape.

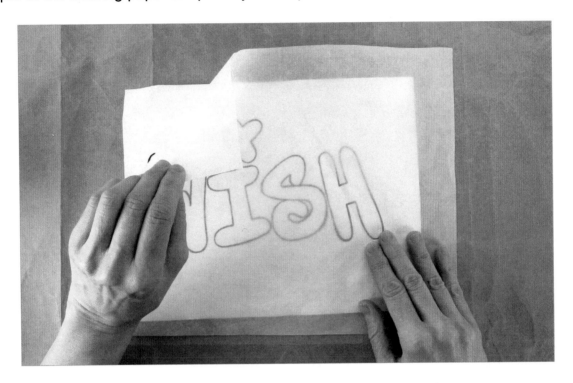

STEP 2. With a semi-sharp tipped pencil or a pen, trace the drawing.

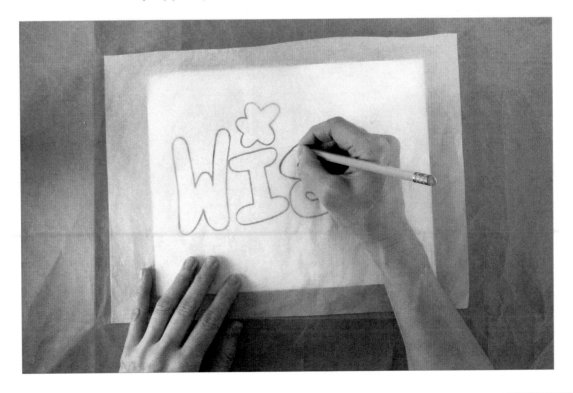

STEP 3. Turn your tracing paper over with the design facing downward. Your word will show through the paper, backward. Put aside the original paper drawing for future signs.

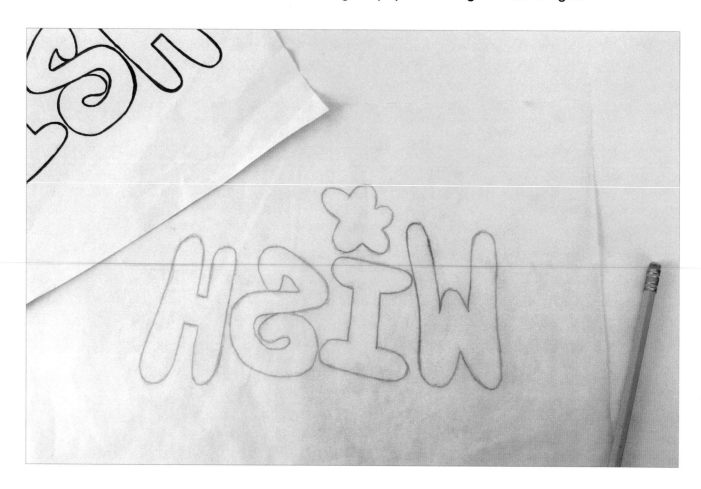

STEP 4. With a semi-sharp pencil trace over the lines of your design on the back of the tracing paper. Press down firmly. Make thick, bold lines. Trace over the whole word design.

NOTE: You may want to place a blank paper underneath the palm of your hand to prevent the pencil lines from smudging as you draw.

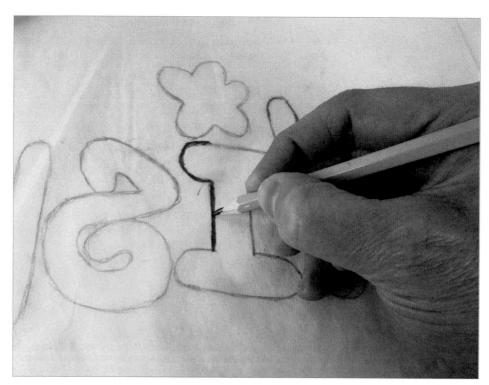

STEP 5. Turn your tracing paper back over to the front. Lay the tracing on top of the wood sign. Tape your paper down over the sign in the location where you want the word to be transferred.

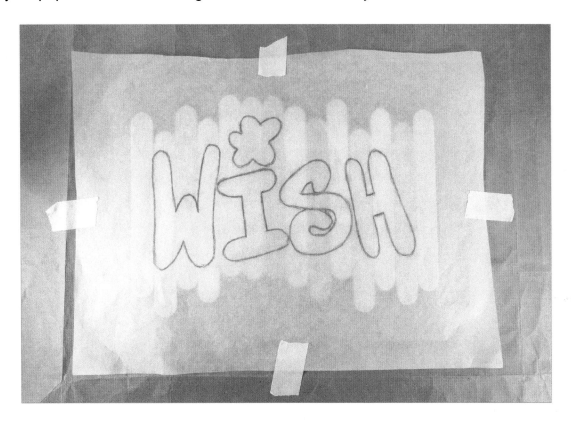

STEP 6. Trace over the lines of the design on the front of the paper. Apply enough pressure to make the pencil lines on the back of the tracing paper transfer onto the wood. Use a pencil with a sharp point or a ballpoint pen. Be careful not to tear through the paper or let it shift position.

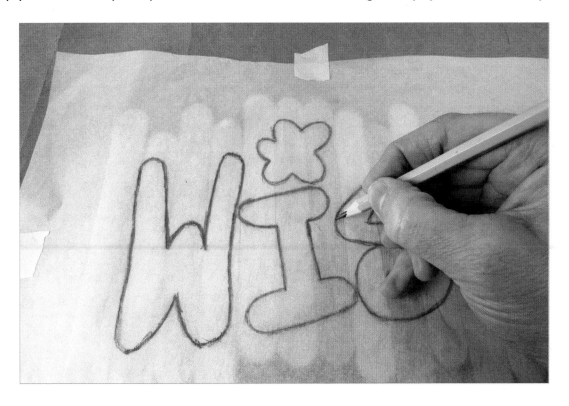

STEP 7. Now the magic part! Remove your paper and the outline of your design has been transferred onto the wood sticks! You'll end up with a clear enough line to see the design fairly well, but you can always darken the line further by drawing over the transfer line with a pencil. Go over any area of the tracing that is too faint or has been missed. Your sign is ready to paint!

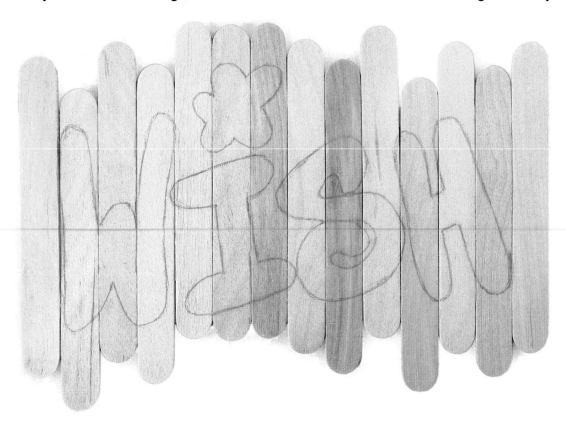

PAINT THE SIGN

STEP 1. Squeeze some white acrylic paint or any other color of your choice onto a paint palette and mix in a little water. With a small brush paint in the letters. Apply several coats.

Use any brand of water-based acrylic paint in jars or bottles

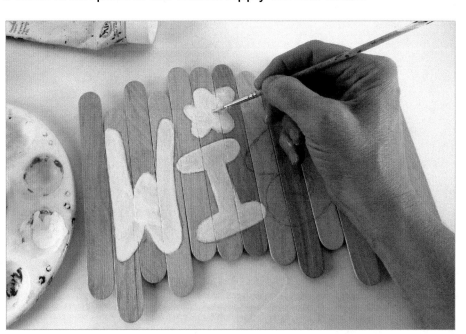

STEP 2. ▶ Paint in the background around the letters with brown paint or any other bright, contrasting color.

You will need to apply several coats of both the letter color and the background color because the wood sticks are pourous and the paint will soak into the wood. Paint as many coats as you need to make both colors stand out.

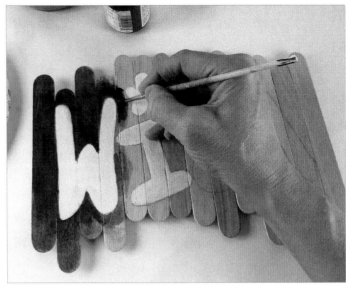

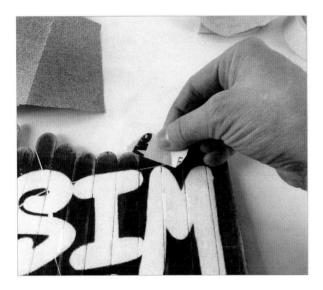

STEP 3. ◀ When the paint is dry, rub the edges of the sticks with a small piece of medium-grade sandpaper. This will remove some of the paint, and give your sign a distressed, worn-out look, like you see on an old sign.

NOTE: VERY IMPORTANT: Always wear a dust mask when you use sandpaper and do your sanding in a well-ventilated area, or go outdoors.

STEP 4. ▶ Mix up some paint (letter color) with water in a small container. Dip a paintbrush into the paint and splatter across the front of the sign. Make some big drops and some small drops. You may want to practice this first on scrap paper to make sure the paint is the right consistency.

STEP 5. When dry, apply a coat of water-based varnish.

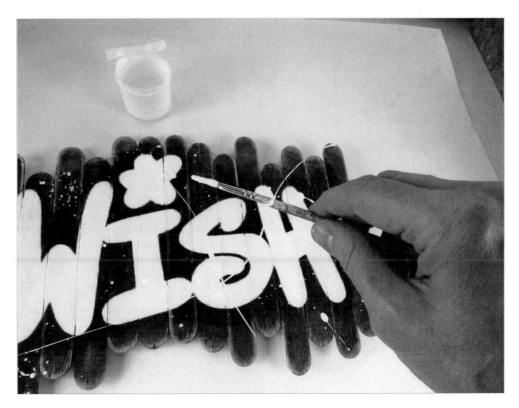

MAKE THE HANGER

STEP 1. To hang your finished sign, cut a piece of string 3x's the width of the sign. Thread some beads onto the ends of the string on each side and tie knots to hold the beads in place.

BACK

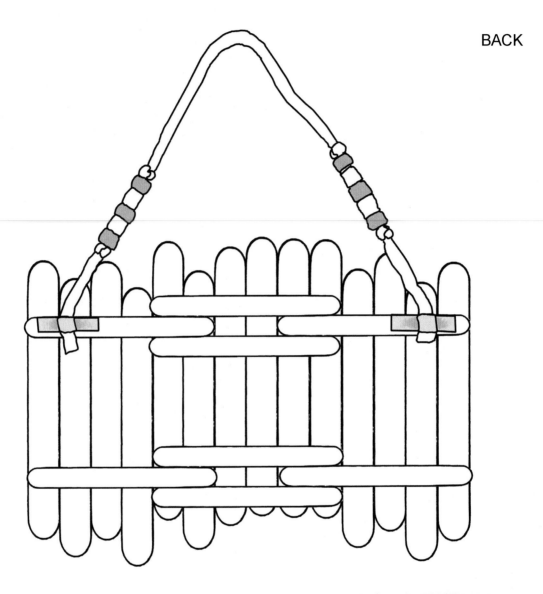

STEP 2. To attach the hanger to the back of the sign, cut two small rectangles of paper and glue them onto the back of the sign with extra thick tacky glue (like little bandaids). Sandwich the ends of the string in between the paper and the wood. I prefer to use brown paper from a grocery store bag, but you can use any kind of paper to make the tabs. Apply a coat of varnish to the paper tabs to make them water-resistant. Trim any excess string from the ends. Let the glue dry thoroughly before hanging.

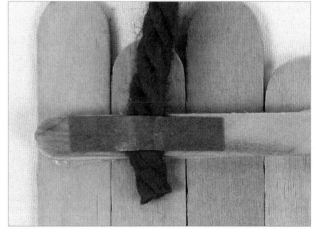

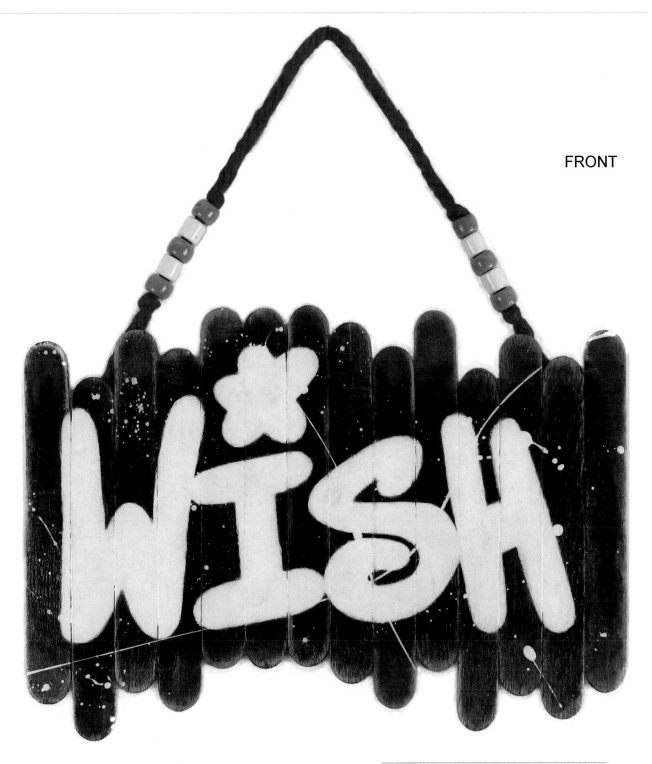

The idea for this sign came from this graffiti tag I found in an old winery in Northern California. You can find inspiration anywhere for your signs. Take photographs when you are out and file them away for future sign ideas.

The full-size pattern for WISH is located back on page 8.

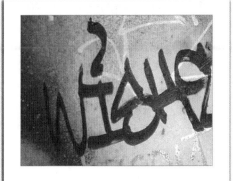

SIMPLE

Front - 17 Jumbo Popsicle Sticks
Back - 12 or 24 Regular Popsicle Sticks

BACK

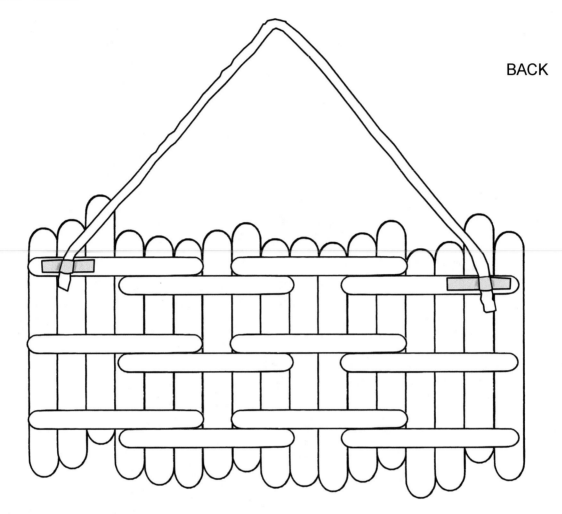

This sign is constructed using the Basic Instructions found on pages 4-15. You can modify the basic technique as needed to fit this word SIMPLE. The crossed sticks on the back of this or any other sign can be doubled for extra strength. Use as many rows as you like. The string is attached to the back of the sign with small tabs of brown Kraft paper and extra thick tacky glue.

INSTRUCTIONS
1. Trace or draw the word design on paper.
2. Cover the letters with popsicle sticks.
3. Put masking tape or temporary blue tape across the front of the sticks (see page 6).
4. Turn over and glue crossed sticks to back (at least two rows). When dry, remove tape.
5. Transfer the word design onto the front using the Pencil Transfer Method (pages 9-12).
6. Paint, varnish, and attach a string to hang.

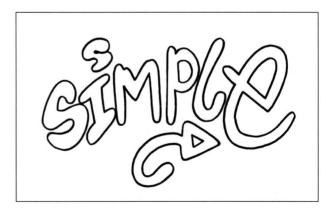

A full-size pattern for SIMPLE is on page 44

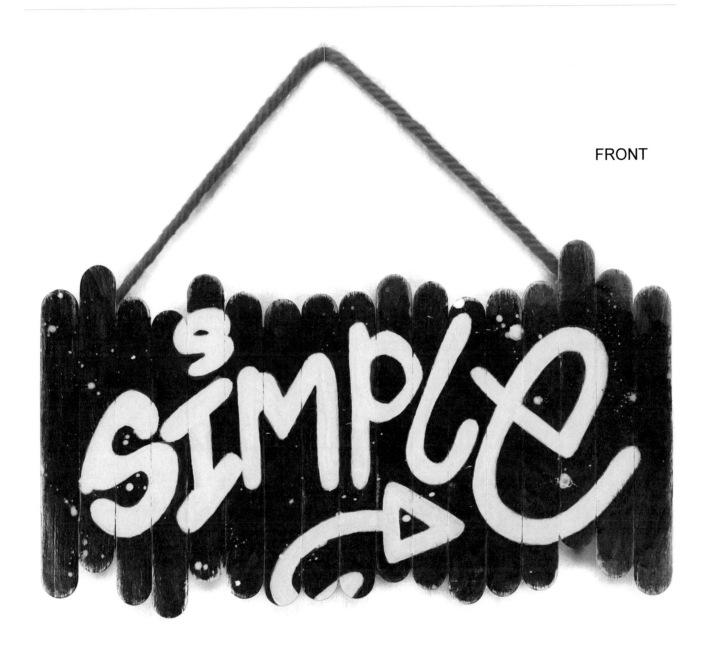

I found this graffiti word SIMPLE at an old theater, The Phoenix, in Northern California. During the day the theater is converted into an indoor skateboard park. Fun place!

A full-size pattern for SIMPLE is located on page 44. Use the Pencil Transfer method detailed on pages 9-12 to make your own SIMPLE sign and paint it in any bright colors you like. It's simple!

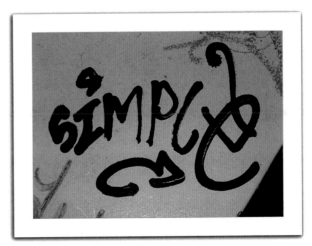

PULSE

Front - 16 Jumbo Popsicle Sticks
Back - 6 or 12 Jumbo Popsicle Sticks
Small Sign - 14 Regular Popsicle Sticks

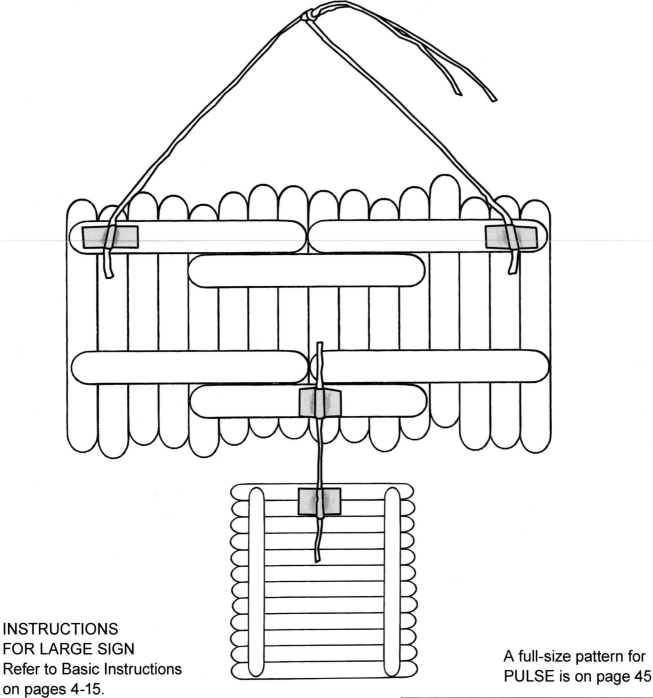

INSTRUCTIONS FOR LARGE SIGN
Refer to Basic Instructions on pages 4-15.

1. Trace or draw the word design on paper.
2. Cover the letters with popsicle sticks.
3. Put tape across the front of the sticks.
4. Turn over and glue interlocking crossed sticks to back. When dry, remove the tape.
5. Transfer the word design onto the front.
6. Paint, varnish, attach a string to hang.

A full-size pattern for PULSE is on page 45

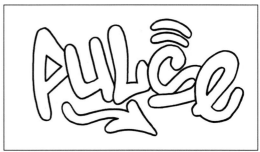

POPSICLE-STICK-GRAFFITI/ NUMBER TWO/ SIGNS

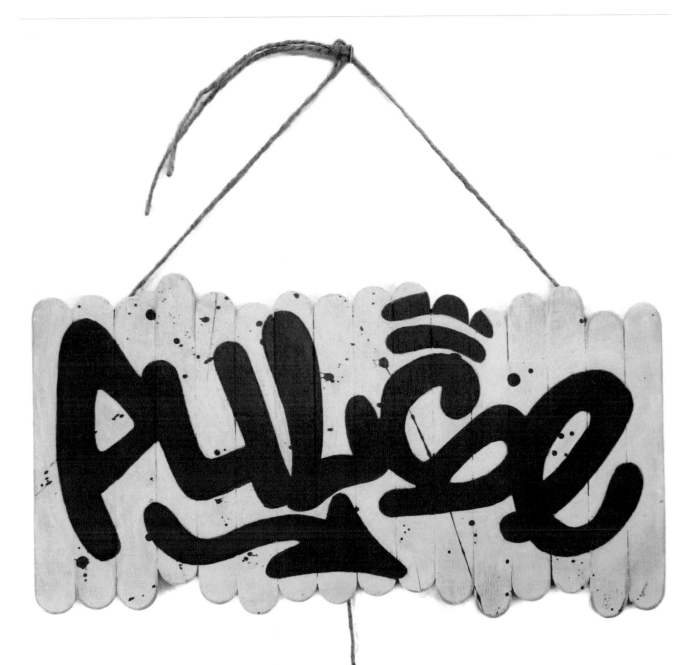

SMALLER SIGN

1. Line up 12 regular popsicle sticks for the front.

2. Glue 2 regular popsicle sticks on the back for the crossed sticks.

3. Draw hearts on the front with a pencil.

4. Paint, then varnish.

5. Attach strings to hang, as shown.

You can rotate the smaller sign and hang this way instead

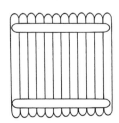

FATE

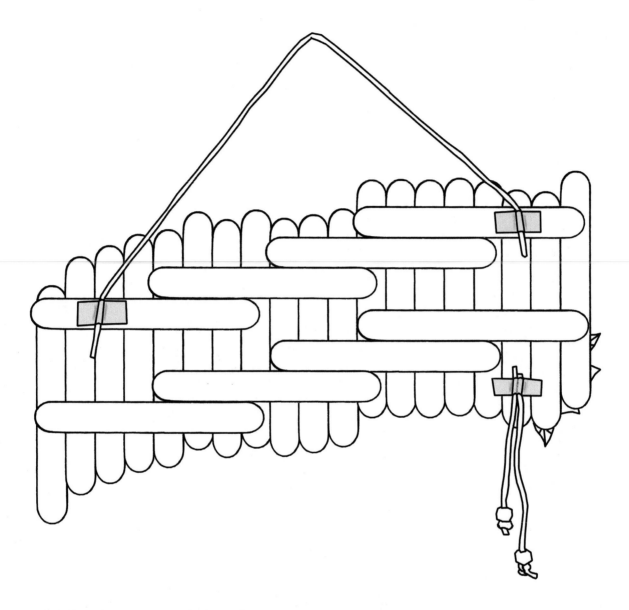

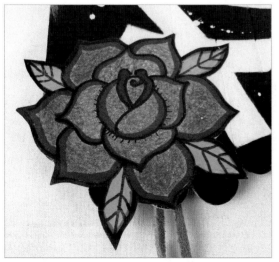

This rose is drawn on heavy-weight cardstock and colored in with magic markers and colored pencils. It is varnished, then cut out when dry. It is attached to the sign front with plain, white glue.

The strings are cut from an old piece of tan rawhide. The two red plastic beads on the left serve as a counter-balance to the down-slanted sign edge on the right.

The edges of the sticks are sanded to make the sign look worn. The paint drips are painted on with a small brush after the sign front is completed.

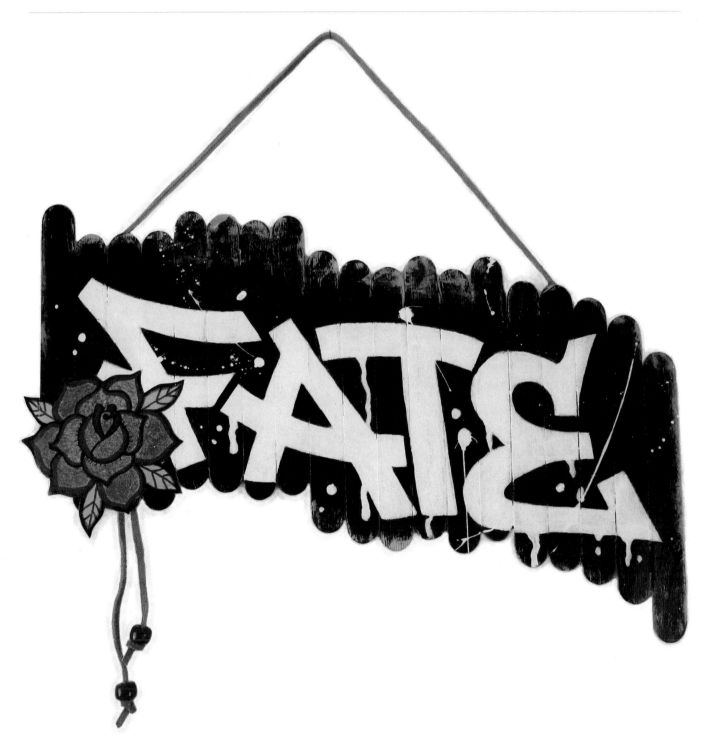

INSTRUCTIONS

Refer to Basic Instructions on pages 4-15.

1. Trace or draw the word design on paper.

2. Cover the letters with popsicle sticks.

3. Put tape across the front of the sticks.

4. Turn over and glue interlocking crossed sticks on back. When dry, remove the tape.

5. Transfer the word design to the sign front.

6. Paint, varnish, and attach the strings.

7. Glue paper rose to the front.

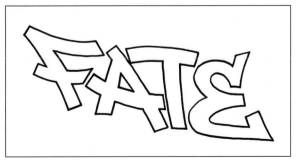

A full-size pattern for FATE is on page 46

METAL

The Union Pacific Railroad runs through the Pacific NorthWest. It is a freight hauling railroad that operates 8,500 locomotives west of Chicago and New Orleans. These trains are amazing to see in person. I don't know how many cars each train has, but it seems like I count past one hundred sometimes. There are plenty of great photographs of freight trains on the Internet.

When these trains roll through in the evening, their whistles echo through the city. It's such an eerie sound. Many of the cars have amazing graffiti pieces painted along the bottoms. Freight trains are a great place to find inspiration for your popsicle-stick-graffiti signs.

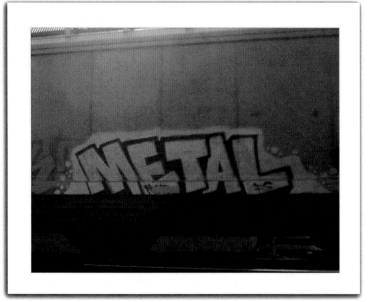

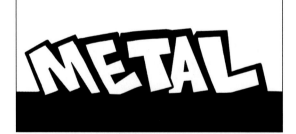

A popsicle stick sign made with freight train graffiti can be constructed with any number of regular popsicle sticks or jumbo sticks on the front or back.

A full-size pattern for this word METAL is on page 47.

22

Front -
32 Regular
Popsicle Sticks

Back -
10 or 20 Regular
Popsicle Sticks

FRONT

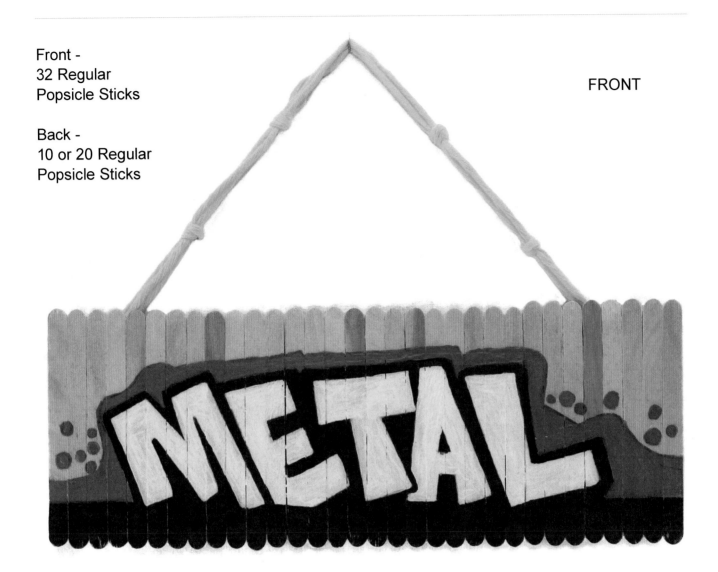

INSTRUCTIONS
Refer to Basic Instructions on pages 4-15.
1. Trace or draw the word design on paper.
2. Cover the letters with popsicle sticks.
3. Put tape on the front of the sticks.
4. Glue interlocking crossed sticks on back. When dry, remove the tape.
5. Transfer the word design onto the front.
6. Paint, varnish, attach a string to hang.

BACK

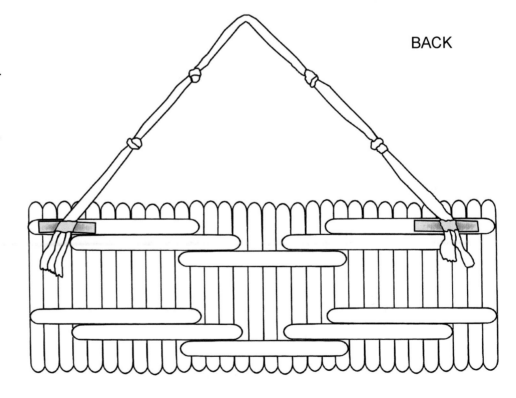

SUP!

Front - 17 Jumbo Popsicle Sticks
Back - 6 or 12 Jumbo Popsicle Sticks

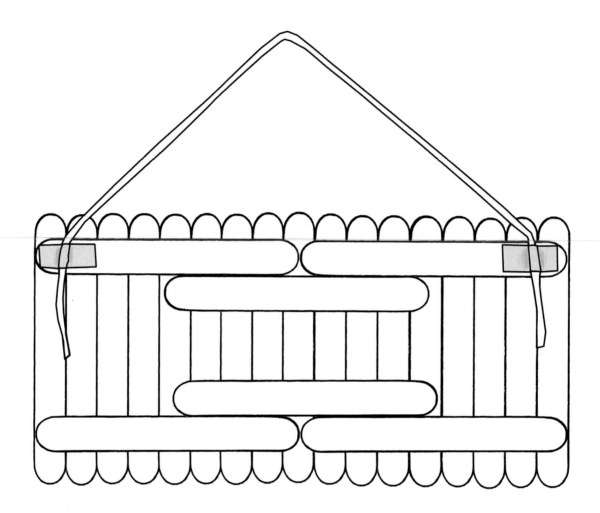

I found this giant graffiti piece on a shipping container in Downtown Portland, Oregon. It reminded me of the graffiti I see on freight trains. A full-size pattern for SUP! is on page 48.

INSTRUCTIONS
Refer to Basic Instructions on pages 4-15.
1. Trace or draw the word design on a sheet of paper.
2. Cover the letters with popsicle sticks.
3. Put tape across the front of the sticks.
4. Turn over and glue interlocking crossed sticks on back. When glue is dry, remove the tape.
5. Transfer the word design onto the front.
6. Paint, varnish, attach a string to hang.

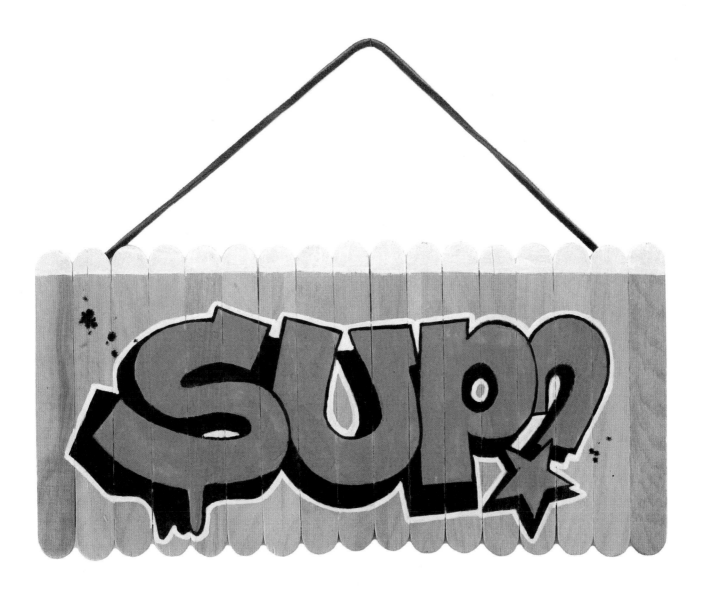

I decided to leave a portion of this sign, as well as the METAL sign on the previous page, unpainted with the natural wood showing. This natural color looks great with a coat of shiny or flat varnish.

The upper tips of the popsicle sticks are painted white to match the white outline around the word. The string is an old piece of rawhide. Nice touch!

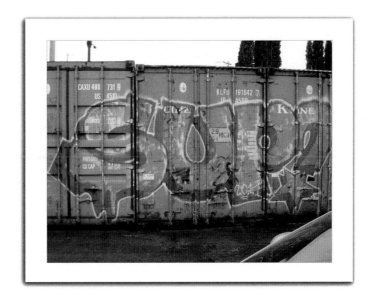

TAG NAMES

Go To Page 40 For Alphabet And More Instructions

STEP 1. Choose a name (it can be a nickname or your initials). Go to the Tag Letter Alphabet on pages 41-43 and pick out the letters you need to complete your name.

Now you have several options:

A) Trace the letters with a pencil directly from this book.

B) Make a photocopy of the pages for easier tracing, then trace the letters.

C) Copy the letters free-hand, by eye.

However you decide to get the letters, when you have them assembled, draw your name on an 8 1/2" x 11" sheet of white paper or tracing paper.

STEP 2. To construct your sign, lay down popsicle sticks on top of the paper over your name. Use as many sticks as needed to cover the letters (see Basic Instructions on pages 4-15 for reference). Put strips of tape across the front of the sticks to hold them in place (see page 6). Turn over and glue crossed sticks to the back in an interlocking pattern of your choice. Use enough crossed sticks to cover the back, end-to-end. When dry, remove the tape from the front.

STEP 3. Transfer your name onto the sign front using the Pencil Transfer Method detailed on pages 9-12.

STEP 4. Paint the letters. Splatter paint. Let dry. Apply a coat of varnish.

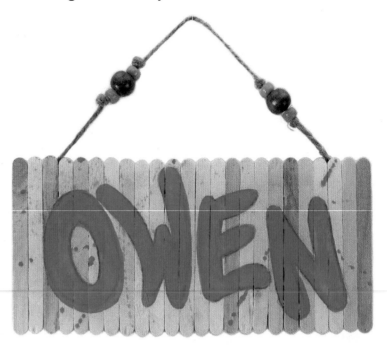

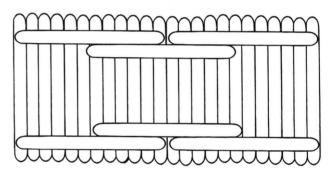

24 regular sticks on front/ 6 or 12 sticks on back

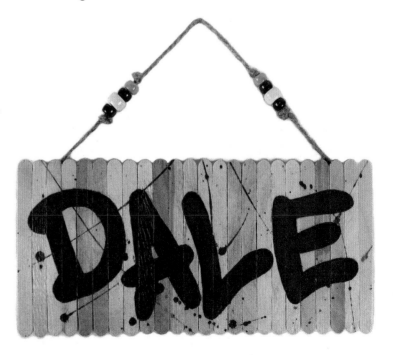

Tag Letter Alphabet Pages 41-43

STEP 5. To hang, attach a string with some colorful beads.

27 regular sticks on front/ 10 or 20 regular sticks on back

26 regular sticks on front/ 8 or 16 sticks on back

POWER

Front - 18 Jumbo Popsicle Sticks
Back - 6 or 12 Jumbo Popsicle Sticks
Wood Dowel

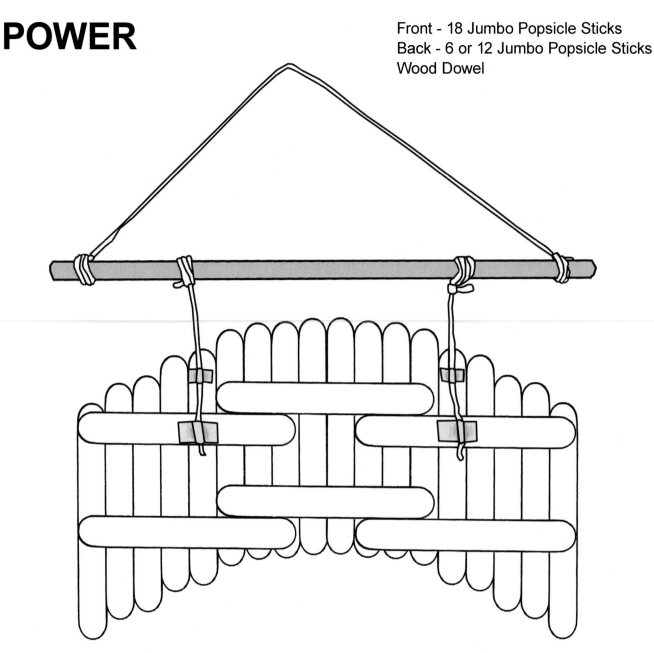

INSTRUCTIONS

Refer to Basic Instructions on pages 4-15.
1. Trace or draw the word design on paper.
2. Cover the letters with popsicle sticks.
3. Put tape across the front of the sticks.
4. Turn over and glue interlocking crossed sticks on the back. When glue is dry, remove the tape.
5. Transfer the word design to the front.
6. Paint sign, varnish, and attach strings.

Attach a wood dowel to the top to give the sign more complexity and add an extra color accent.

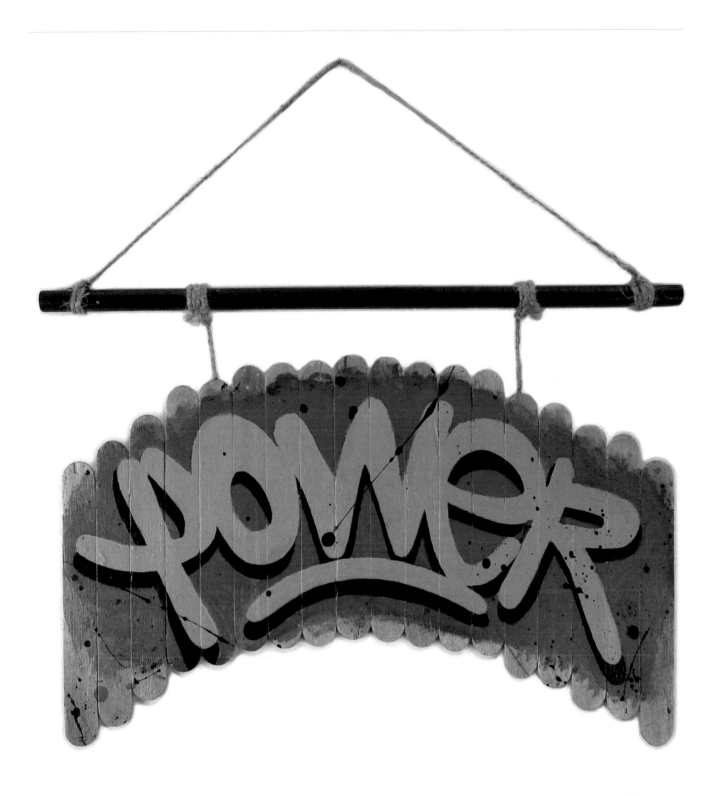

I found this mailbox on a street in New York City. I am not 100% sure if the graffiti scribbled on top says POWER, but that's what it made me think of when I got home and viewed the photograph later.

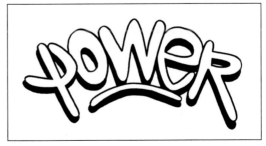

Full-size pattern POWER on page 49

KARMA

Front - 11 Regular Popsicle Sticks
12 Jumbo Popsicle Sticks
Back - 10 or 20 Regular Popsicle Sticks
Small Signs - 42 Regular Popsicle Sticks
Wood Dowel

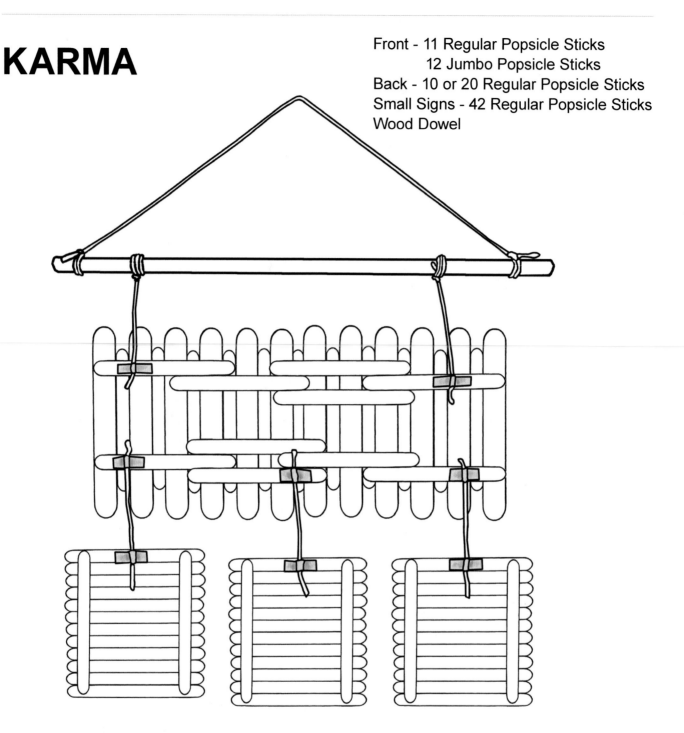

The large sign has regular popsicle sticks and jumbo popsicle sticks alternating on the front. Crossed sticks on back are regular size sticks.

INSTRUCTIONS FOR LARGE SIGN
1. Trace or draw the word design on paper.
2. Cover the letters with popsicle sticks.
3. Put tape across the front of the sticks.
4. Glue crossed sticks to back. Remove tape.
5. Transfer the word design to the front.
6. Paint, varnish, attach strings and dowel.

The wood dowel on top adds a white accent and ties the whole design together. Gold string provides a touch of sparkle.

SMALL SIGNS
1. Construct signs with regular size sticks.
2. Trace patterns from page 50 (adjust sizes if needed), and transfer to small signs using the Pencil Transfer Method (see pages 9-12).
3. Paint with acrylic paint, then varnish.
4. Attach strings with paper tabs and glue.

Full-size patterns for
KARMA and shapes
on page 50

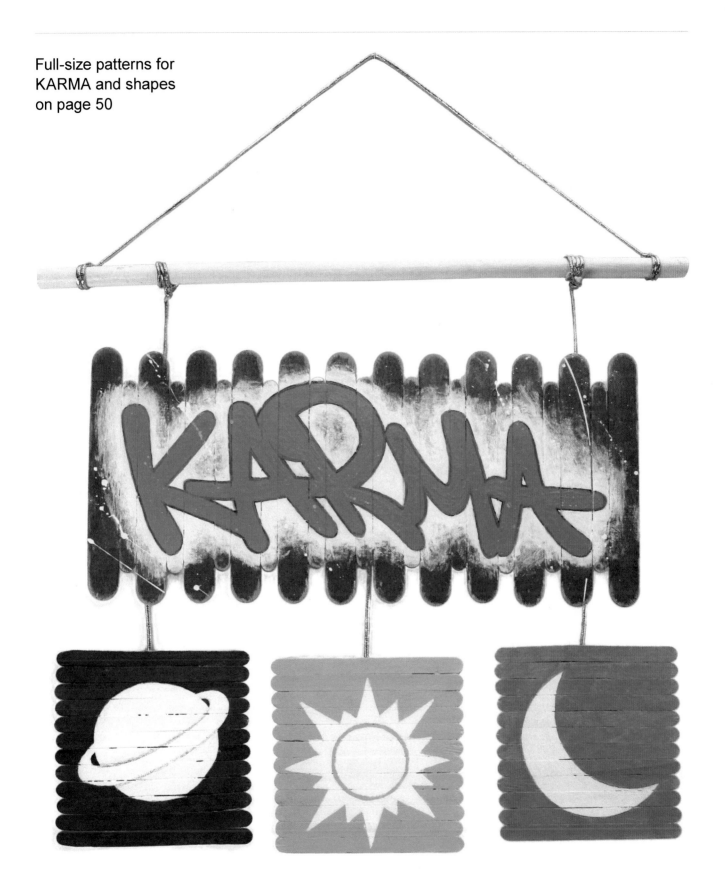

Alternate Idea #1- Decorate the large sign with a family's last name. Embellish the smaller signs with photographs of family members, mementos from a trip, or quotes.

Alternate Idea #2- Decorate the large sign with the name of a favorite pet. Decorate the smaller signs with photographs of pet, pet friends, paw prints, or drawings.

IMAGINE

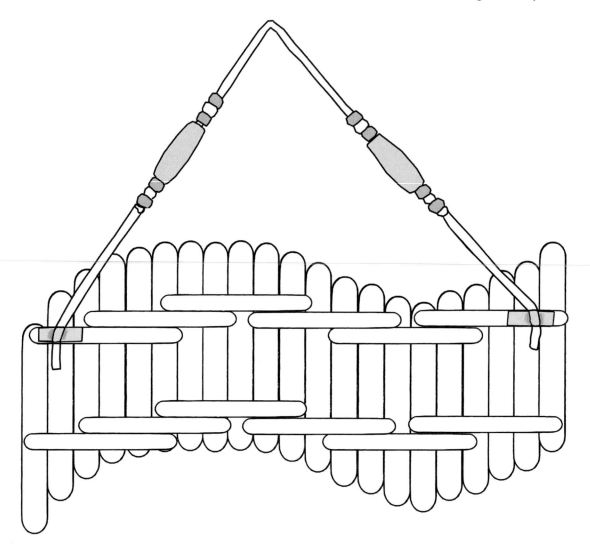

This sign has the most complex shape of all the signs in this book. It is constructed in the same way as other signs but requires a bit of pre-planning to make sure all the parts work together.

Lay out the sticks and adjust the letters in your drawing to fit along the curve of the sticks before attaching the crossed sticks to the back with glue. Adjust both the drawing and sticks as needed to get the right fit.

INSTRUCTIONS
Refer to Basic Instructions on pages 4-15.
1. Trace or draw the word design on paper.
2. Cover the letters with popsicle sticks.
3. Put tape across the front of the sticks.
4. Glue crossed sticks to the back. Remove tape.
5. Transfer the word design onto the front.
6. Paint, varnish, and attach a string with beads.

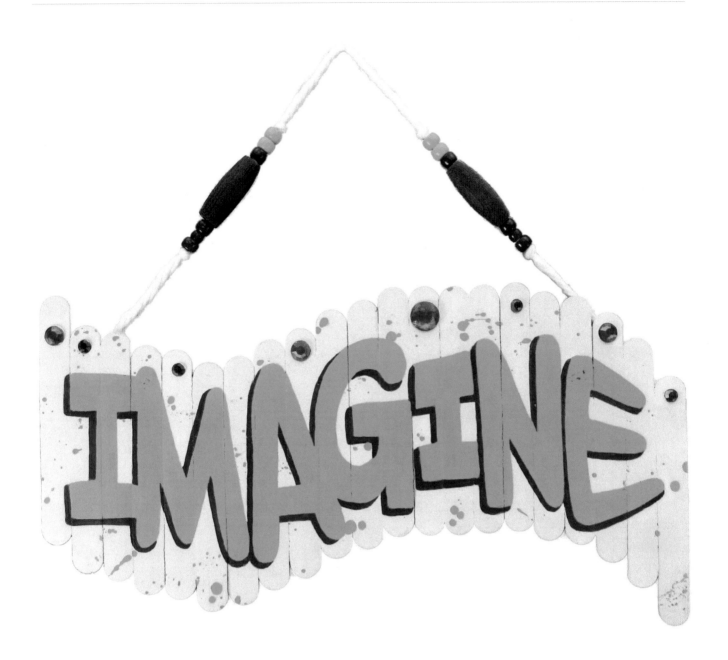

I found some old emerald colored rhine-stones to embellish this sign and glued them on with thick tacky glue. You can decorate your sign with anything you like, especially eye-catching, shiny doodads.

A full-size pattern for IMAGINE is on page 51. You will need to adjust the pattern size for jumbo sticks, using one of the tips on page 40. Or you can make up your own word to fit on this fun, curving sign style.

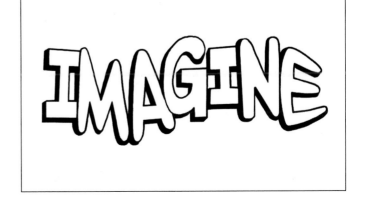

KISS

Front - 18 Jumbo Popsicle Sticks
Back - 10 or 20 Regular Popsicle Sticks
Tree Branch

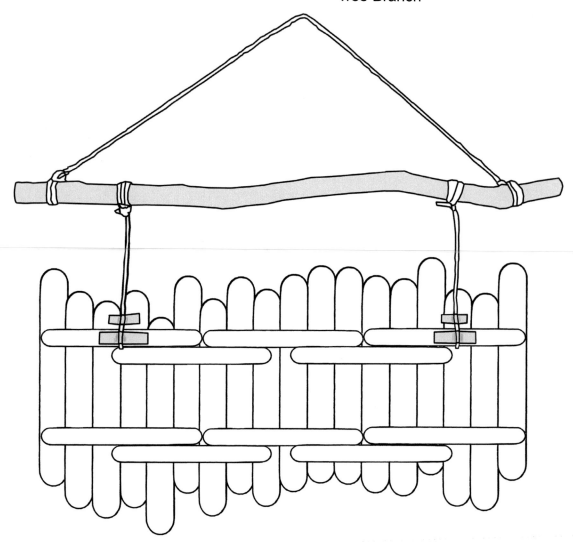

A tree branch hanger makes a perfect rustic accent for this worn-out looking sign.
1. Wash branch with a disinfectant cleaner.
2. Sand off rough spots with medium sandpaper.
3. Paint with a watery coat of brown paint to even out the color. 4. When dry, apply varnish.

INSTRUCTIONS FOR SIGN
Refer to Basic Instructions on pages 4-15.
1. Trace or draw the word design on paper.
2. Cover the letters with popsicle sticks.
3. Put tape across the front of the sticks.
4. Glue crossed sticks to back. Remove tape.
5. Transfer the word design onto the front.
6. Paint, varnish, attach branch and strings.

Lilac colored rhinestones are glued on to the top corners to provide a contrasting touch of sparkle.

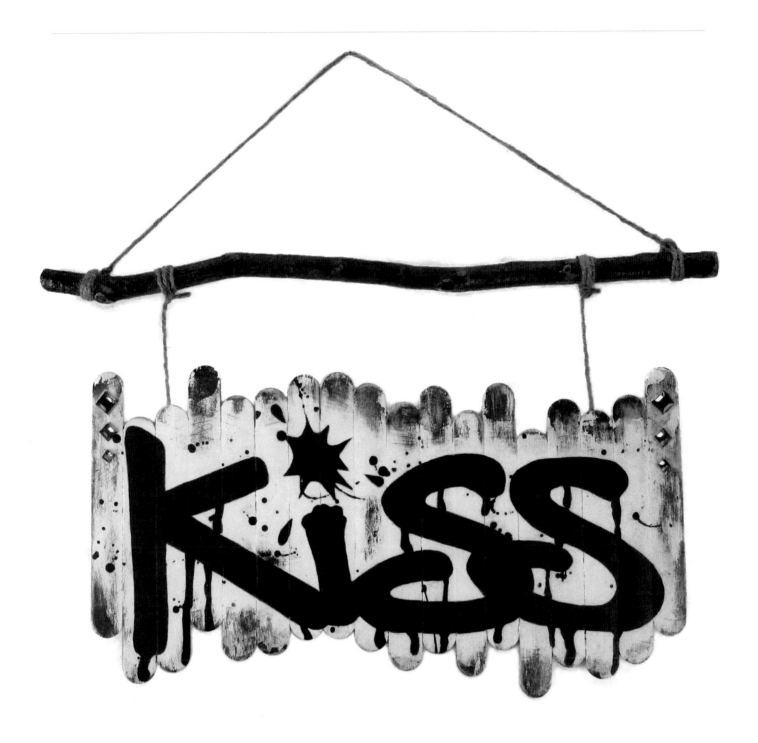

I painted this sign with several coats of acrylic paint (first coat- brown paint, second coat- purple paint, third & fourth coats- white paint). When dry, I took it outside and sanded off the paint in different areas, so the colors underneath would show through. NOTE: Always wear a dust mask and sand in a well-ventilated area, or go outdoors.

This is a sophisticated looking sign, but the steps to create it are basically the same as all the other signs in this book, plus lots of extra sanding!

A full-size pattern for KISS is on page 52

WELCOME

Front - 21 Jumbo Popsicle Sticks
Back - 9 or 18 Jumbo Popsicle Sticks

IN THIS UNIQUE SIGN STYLE THE
POPSICLE STICKS ARE PAINTED
BEFORE THE SIGN IS ASSEMBLED

INSTRUCTIONS

1. Paint the jumbo popsicle sticks for the
front with two or more colors. Allow the
paint to dry. Add a second coat if needed.

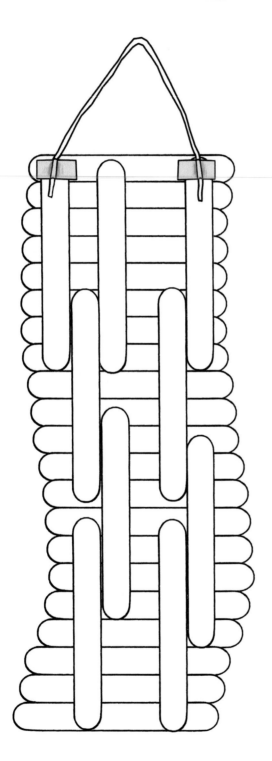

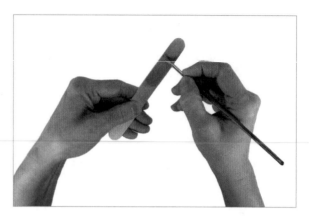

2. Trace the letters W-E-L-C-O-M-E from
the Tag Letter Alphabet on pages 41-43
onto a sheet of paper. Arrange them
<u>vertically</u>, in whatever pattern you like.

3. Cover the letters on the paper with the
painted popsicle sticks. Arrange them ver-
tically in a waving pattern, as shown.

4. Put tape across the front to hold sticks
in place. Glue interlocking crossed sticks
to the back. When dry, remove the tape.

5. Use the Pencil Transfer Method de-
tailed on pages 9-12 to transfer your let-
ters from your paper onto the front of the
pre-painted sticks.

6. Paint the letters of the word with a color
that stands out from the background col-
ors. Paint a bright outline color around the
letters to make them stand out even more.
Splash the front with both colors of paint.

7. Apply a coat of varnish. Attach a string,
then decorate with rhinestones or sequins.

Go to Tag Letter Alphabet
on pages 41-43

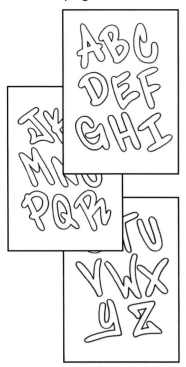

Trace letters onto regular
paper or tracing paper

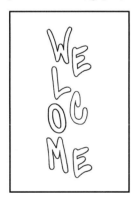

Embellish with rhinestones

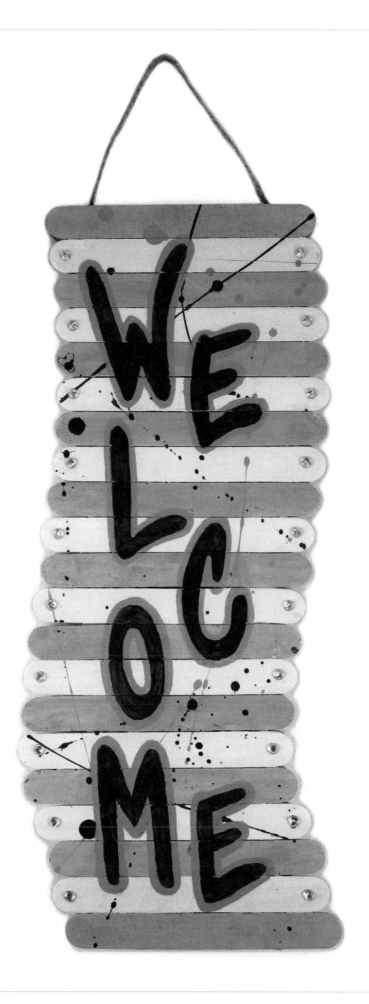

BROS

Front - 17 Jumbo Popsicle Sticks
Back - 10 or 20 Regular Popsicle Sticks

POPSICLE STICKS ARE
PAINTED **BEFORE** THE
SIGN IS ASSEMBLED

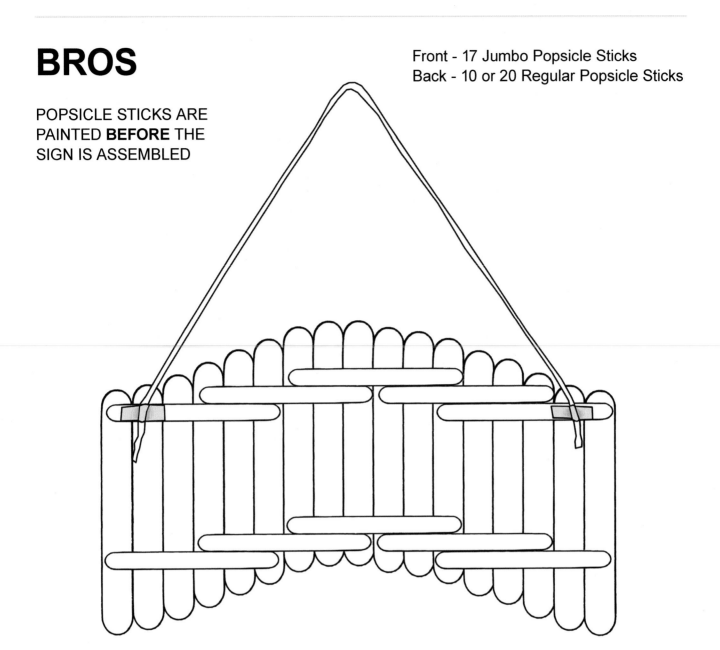

This BROS sign is similar to the WELCOME sign on the proceeding page in that the jumbo
sticks for the front are painted before the sign is assembled. Several different shades of brown
acrylic paint are used - Burnt Sienna, Raw Sienna, Burnt Umber, and Raw Umber - straight from the tubes and thinned with water, to create this stunning, wood-colored effect. After the paint is dry, then the sign is constructed.

The sticks are arranged on a curving baseline like the POWER sign on page 28 (use same instructions). The word design is transferred onto the painted sticks with the Pencil Transfer Method (pages 9-12). The letters are painted with several coats of black & white acrylic paint.

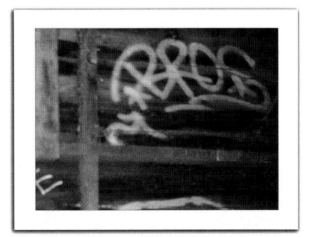

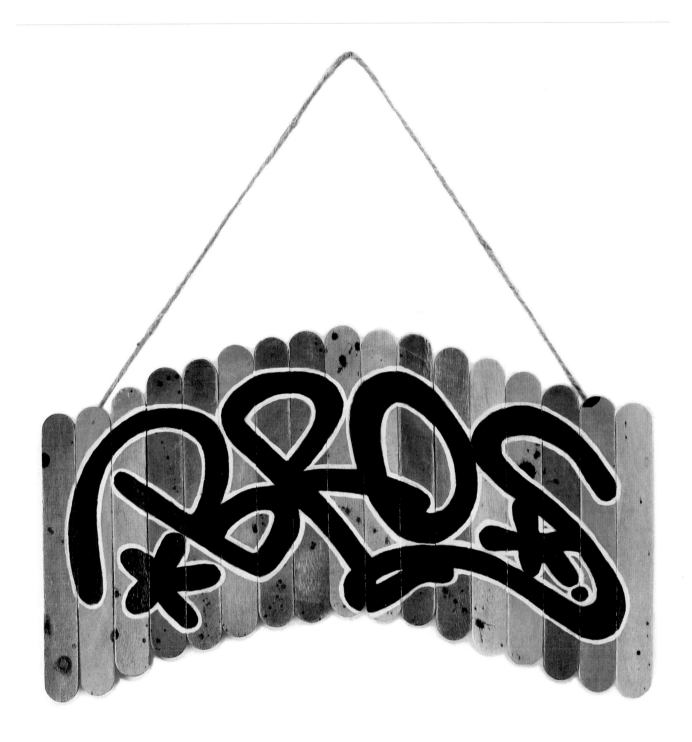

I found this BROS graffiti tag tucked away in a dark, spider-webby corner of an old barn. Who knows who the Bros were who painted it, or how long it was there. No matter, it made for a great sign with which to end this part of the book. Thanks, Bros!

A full-size pattern for BROS is on page 53.

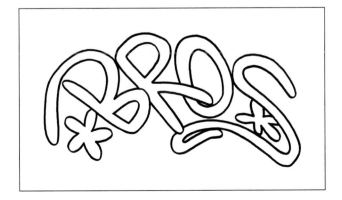

TAG LETTER ALPHABET: PAGES 41-43

TAG NAMES - FROM PAGES 26-27

STEP 1. There are several different ways you can use these letters. You can:
A) Trace the letters that you need out of this book onto a piece of drawing or tracing paper.
B) Make a photocopy of the pages and trace the letters.
C) Copy them by eye, free-hand.
D) Cut the letters or pages out, and then trace the letters you need.
E) Use these letters as a foundation and change them to create your own unique letters.
When ready, draw your name on an 8 1/2" x 11" sheet of paper or a piece of tracing paper.

STEP 2. To build the sign, cover the letters of your name on the paper with popsicle sticks (see Basic Instructions on pages 4-15 for reference). Put masking tape or blue tape across the front. Turn over and glue interlocking crossed sticks to the back in any arrangement you like.
FRONT - Use as many popsicle sticks as needed to accommodate the length of your name.
BACK - Use as many crossed sticks on back as needed, end-to-end, to hold the sign together.
STEP 3. Transfer your name onto the sign using the Pencil Transfer Method (see pages 9-12).
STEP 4. Paint, let dry, then varnish. **STEP 5.** Attach a string with some colorful beads to hang.

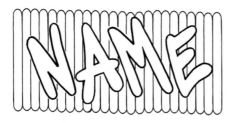

NAME ON FRONT OF SIGN

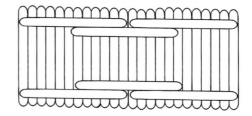

CROSSED STICKS ON BACK

WORD PATTERNS: PAGES 44-53

These pages contain full-size patterns for the words in this book. You may trace the designs directly out of the book and transfer them onto your signs using the Pencil Transfer Method detailed on pages 9-12. You can also photocopy the pages, then trace them, to make it easier.

If a word design is not the right size for the sign you want to make, you will need to adjust the size to fit correctly. Here are several different methods you can use to adjust the size:
A) Take a photograph of the word, download it to your computer, and use your photo-editing program to modify the size of the word.
B) You can scan the page and alter the size with a photocopy machine.
C) Make a copy, cut the word design into pieces, and move the pieces around to make the word fit on the sign. Then trace the new word in the correct size on a new piece of tracing paper.

When your word design is ready refer to the Basic Instructions on pages 4-15 to build your sign. Modify the instructions as needed to fit whichever shaped sign and word you are working with.

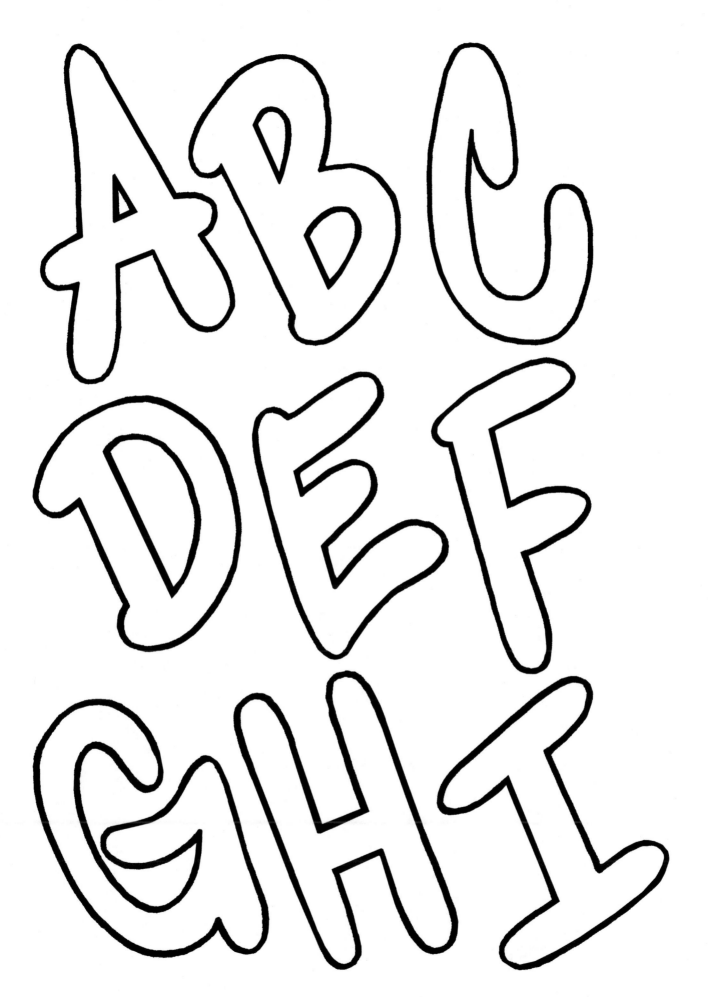

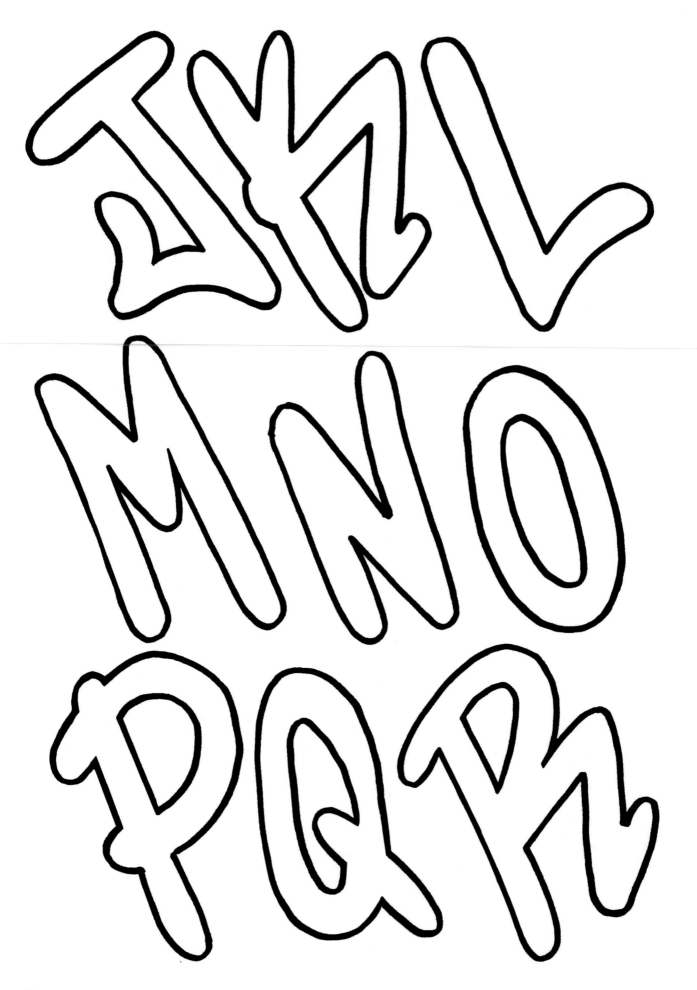

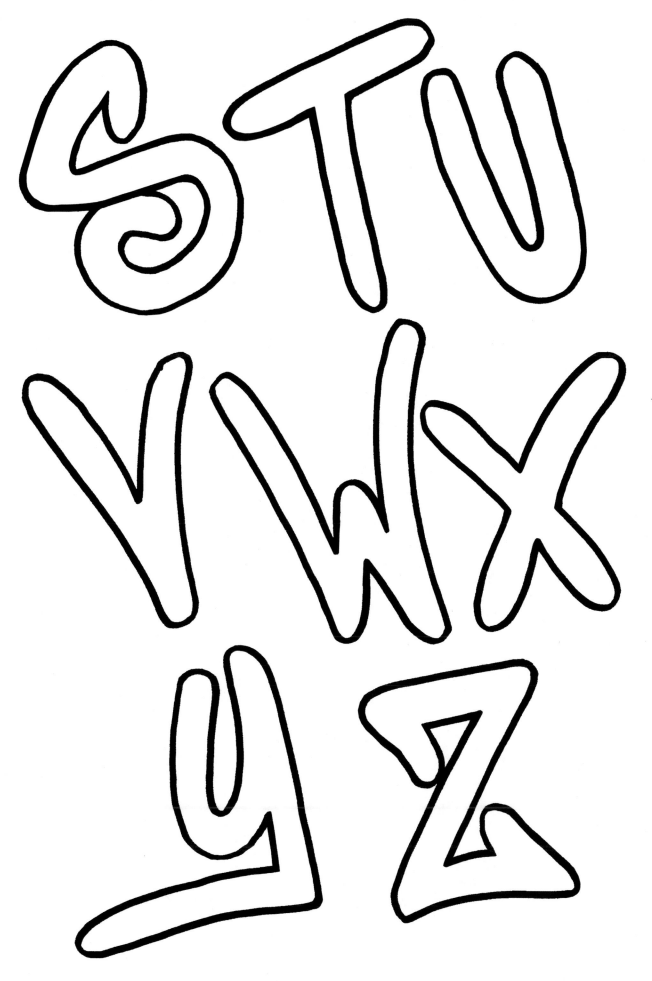

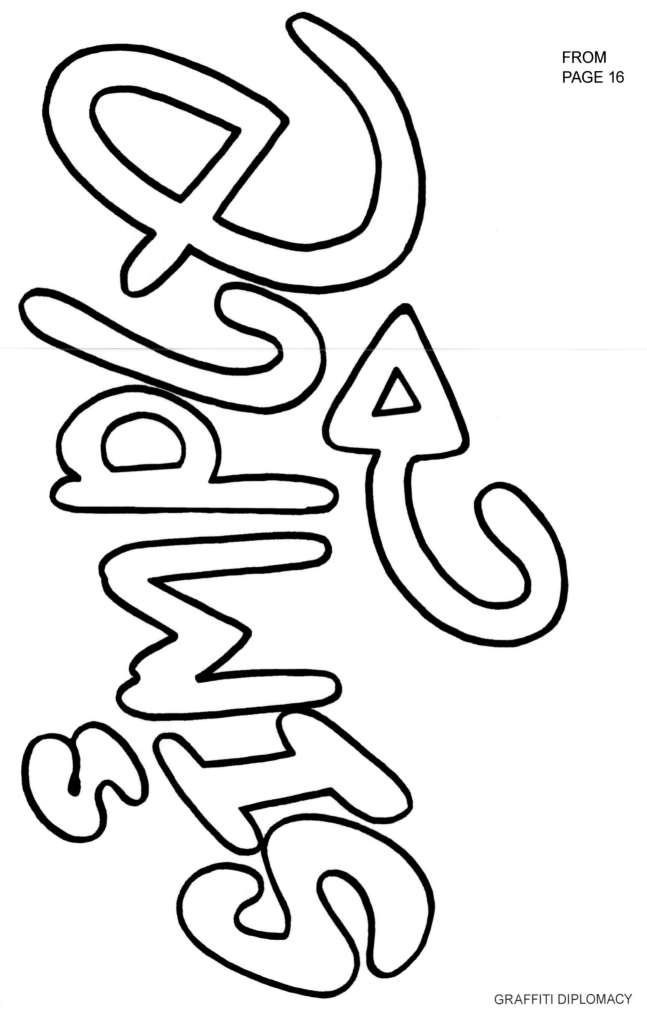

FROM
PAGE 20

Will fit on regular size popsicle sticks. Needs to be enlarged to fit on jumbo sticks.

FROM
PAGE 22

GRAFFITI DIPLOMACY

GRAFFITI DIPLOMACY

FROM
PAGE 28

Will fit on
regular
size
popsicle
sticks.
Needs
to be
enlarged
to fit on
jumbo
sticks.

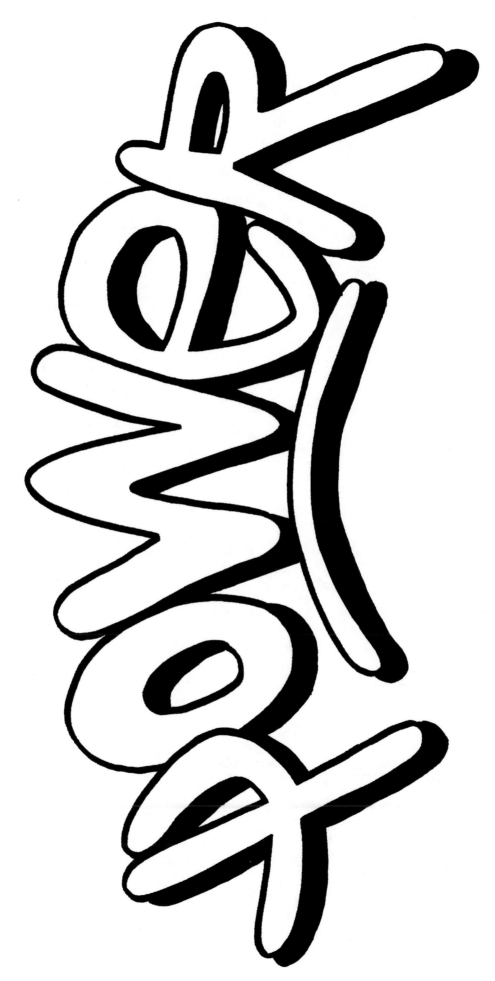

FROM
PAGE 30

Enlarge
patterns
slightly if
possible

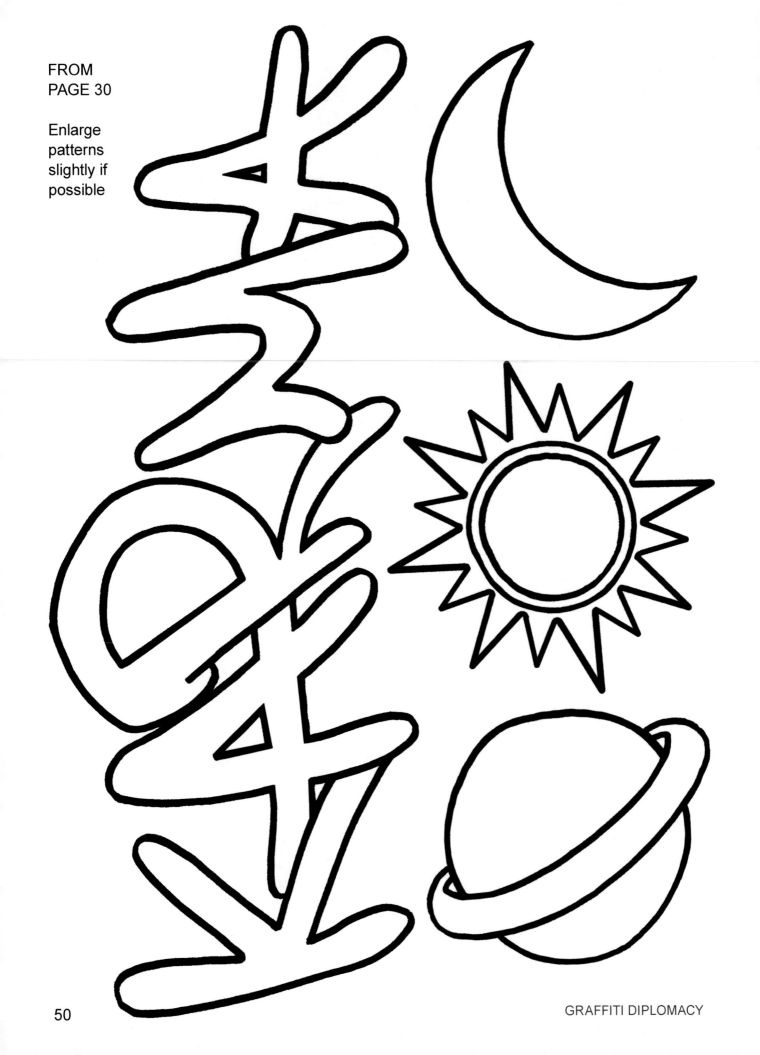

FROM
PAGE 32

Will fit on
regular
size
popsicle
sticks.
Needs
to be
enlarged
to fit on
jumbo
sticks.

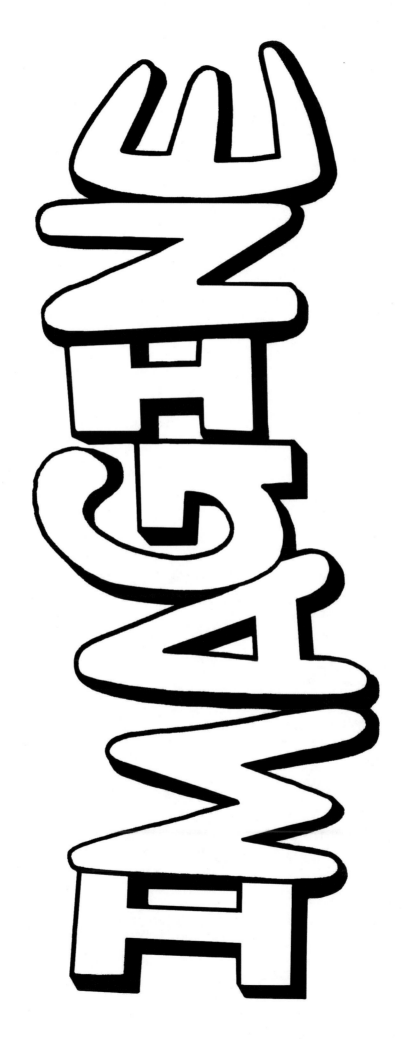

GRAFFITI DIPLOMACY

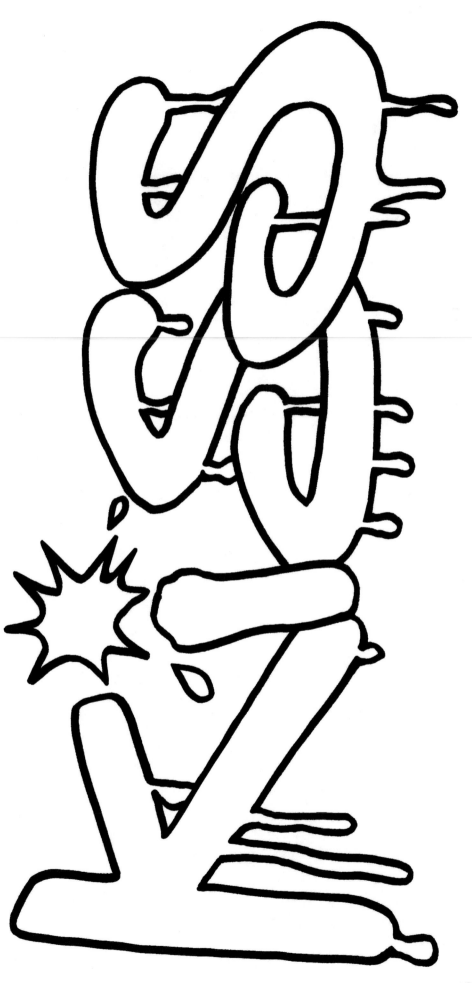

Needs
to be
enlarged
for jumbo
popsicle
sticks

GRAFFITI DIPLOMACY

Made in the USA
Monee, IL
28 September 2021